D1321459

TRADITIONAL
COOKING

SICILY

FAVOURITE RECIPES

SIME BOOKS

CONTENTS

Recipe difficulty:

◼◻◻ easy

◼◼◻ medium

◼◼◼ hard

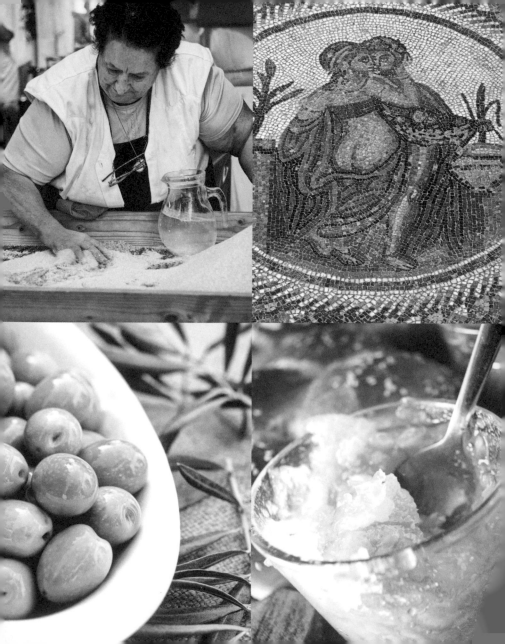

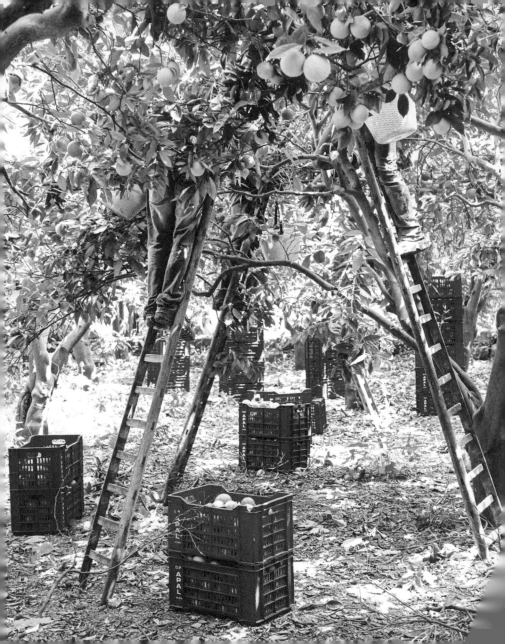

THE REGION OF FLAVOURS

The cuisine of Sicily takes its flavours from the sea, land and mountains. Its unique mixture of tastes is also the product of an overlapping of the different cultures that, over thousands of years, have made Sicily a crossroads between the culinary traditions of the Western and Arab worlds. And behind it all is local produce of exceptional quality – foods that give life to a cuisine that can be simple or complex, rustic or refined.

From the land...

With Sicily's climate and natural diversity, the region produces excellent food products, many of which have earned DOP (protected designation of origin) and IGP (protected geographical indication) certification as well as the Slow Food stamp of approval. While **blood oranges** – whose local varieties include the Tarocco, Moro and Sanguinello – have become a symbol of the region's extraordinary richness, Sicily is also a major producer of **lemons**, **mandarins**, **aubergines** (the key ingredient of an endless variety of dishes here), **tomatoes**, **prickly pears** and **table grapes**. Sicily also grows **almonds** (the Pizzuta variety from Avola forms the basis of many desserts), **pistachios** (the ones grown in Bronte are exported all over the

world), **capers** (the most famous are grown in Pantelleria, but they're also produced on the Aeolian Islands) and an infinite variety of wild herbs. Sicilian olive oils are classified into six DOP (protected designation of origin) areas: Monti Iblei, Monte Etna, Val di Mazara, Valdemone, Valle del Belice and Valli Trapanesi.

...and the sea

Recalling our age-old quest to tame nature and the sea, the ancient *mattanza* **tuna** fishing technique is still practiced here. Although nowadays catch numbers have been tightly reduced, the sea still provides the island with superb tuna. *Feluca* is the name of the unique fishing boat used for catching **swordfish**, and this species' numbers are particularly high in the Strait of Messina. But the Sicilian seas also teem with **shellfish**, **sardines** and **cod**.

Cheese and meat

While ricotta is famous for desserts (cannoli and cassata, in particular), you should never overlook Sicily's other cheeses. **Sicilian pecorino**, made from full-cream milk from the local sheep breed, is firm with a strong flavour, making it ideal for many dishes as well as a topping for pasta. This variety

is called *tuma* when fresh and unsalted, *primosale* once salted and *canestrato* after aging. **Ragusa caciocavallo** is made exclusively from milk from the Modicana cattle breed and exclusively in the province of Modica. This distinctive box-shaped cheese with its semi-hard consistency has a delicate flavour at the beginning of aging and a very sharp edge when older. The **Nebrodi** and **Madonie** varieties of **provola**, **Vastedda del Belice** (the only pulled-curd sheep's milk cheese) and **Maiorchino pecorino** (wheels of which are used in a famous cheese rolling race) all carry the Slow Food stamp of approval. Besides providing milk for caciocavallo cheese, the rare **Modicana cattle breed**, which lives in the wild, supplies delicious meat

Honey and chocolate
The **honey** produced throughout Sicily is particularly high quality and includes delicious citrus, thyme, carob and other varieties. Produced using traditional techniques, but available in an infinite number of varieties, **Modica chocolate** is an absolute feast for the taste buds.

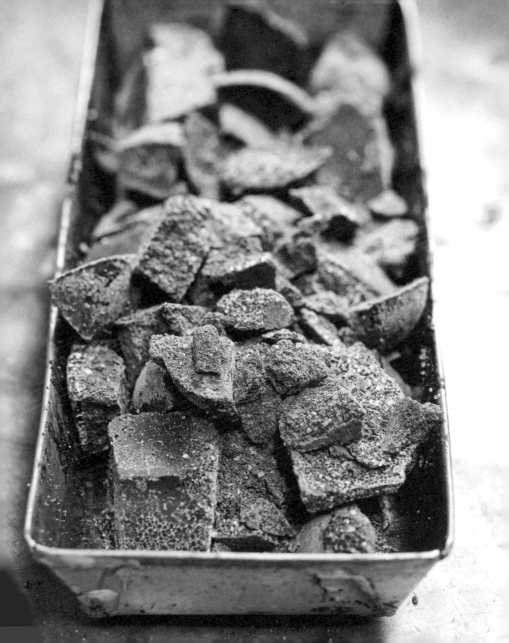

ANTIPASTOS AND STREET FOOD

'LAND FISH'

Serves 4
- 2 fennels
- 1 onion
- 12 sage leaves
- maize oil
- salt
- pepper

Batter:
- 1 egg
- 350g (3 cups) durum wheat flour
- 150g (²/₃ cup) cold
- sparkling water

Prepare the batter with the flour, egg and water. Refrigerate for 1 hour.

Cut the onion and fennels into 1 cm wide slices.

Dip the sage leaves and the vegetables individually into the batter and fry in boiling oil until golden.

Salt and pepper to taste.

Almerita 2006 - Contea di Sclafani DOC Spumante, Cantina Tasca d'Almerita, Sclafani Bagni (Palermo)

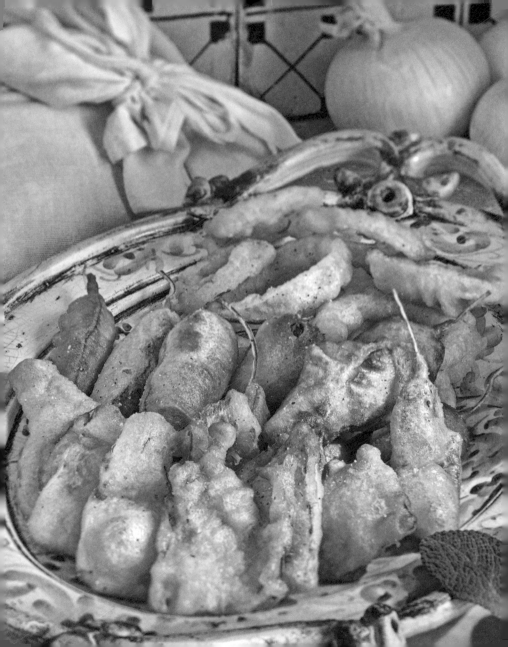

Serves 4
Sauce:
- 700g (1²/₃ lbs)
 veal (single piece of
 breast)
- 250g (1¹/₄ cups)
 tomato paste
- 2 onions
- 1 celery stick
- 2 carrots
- 150g (1 cup)
 blanched peas
- 3 bay leaves
- 3 cloves
- 1 pinch cinnamon
- a little grated
 nutmeg
- 1 orange peel dried
 in the oven
- red wine
- extra virgin olive oil
- salt
- pepper

RICE BALLS WITH MEAT SAUCE FILLING

Sauce (prepare the day before):
Over a low heat, fry the onion, finely chopped carrot and celery in olive oil until golden brown.

Add the meat. Brown on all sides then pour the wine over the top.

Add hot water and the tomato paste, previously dissolved in some of the hot water, to cover three quarters of the meat.

Add the bay leaves, orange peel and all the spices.

Bring to the boil over a very low heat and let simmer for at least 3 hours. If necessary, add more wine.

After three-quarters of the cooking time, add the peas. Season with salt and pepper.

Once cooked, remove the meat from the sauce and dice or shred it.

Remove the cinnamon, cloves, orange peel and bay leaves from the sauce.

Allow to cool. Skim off the fat. Return the pieces of meat to the sauce and mix well.

Rice balls:
- 500g (2¹/₃ cups)
 Carnaroli or Vialone
 Nano rice
- 150g (5¹/₄) fresh
 pecorino cheese
 in small cubes
- 50g (¹/₂ cup)
 pecorino cheese,
 grated
- 50g (¹/₂ cup)
 breadcrumbs
- 3g (2 pinches)
 saffron pistils
- 00 flour
- iced water
- extra virgin olive oil
 (or pork lard)

Rice balls:
Boil rice in salted water until al dente.

Immediately after draining, add the grated
pecorino cheese and the saffron soaked in
a small amount of hot water.

Prepare a batter with the flour and iced water.

Put a handful of rice in your left hand and
flatten with a spoon. Place a teaspoon of
sauce and a small amount of fresh pecorino
cheese in the centre. Cover with the same
amount of rice and seal the sauce inside,
being areful to avoid leaks. Shape into a cone
or ball and dip n the batter and then the
breadcrumbs.

Heat the oil or lard in a saucepan. Fry the rice
balls until the breadcrumbs are golden brown.

Bake in a hot oven (210°C - 410°F) for
approximately 10 minutes. Serve warm.

Arturo di Lanzeria 2006 - Sicilia IGT Rosso
Azienda agricola Guccione, San Cipirello (Palermo)

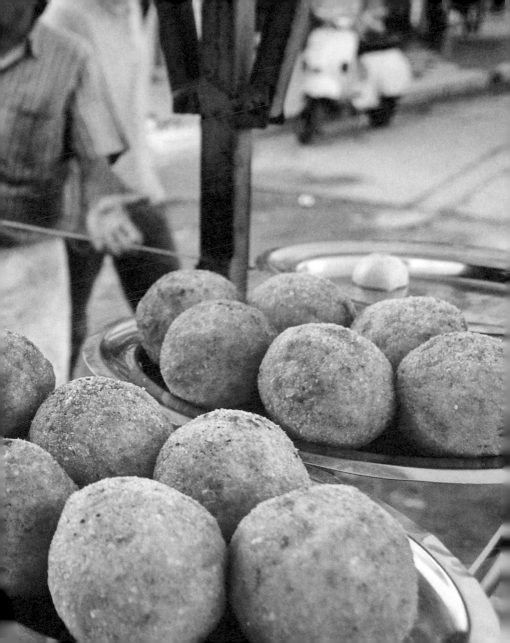

CUNZATU BREAD

Serves 4
- 12 slices of slightly
 old good bread
- 8 tomatoes
- 2 cucumbers
- 2 cloves garlic
- a few basil leaves
- oregano
- extra virgin olive oil
- salt
- pepper

Dampen the bread with water.

Slice the tomatoes and cucumbers.

Soak the garlic cloves in olive oil for 1 hour.

Layer the slices of bread, tomatoes and cucumbers, and season with the basil leaves, oregano, salt and pepper. Drizzle plenty of the garlic-flavoured oil over the top.

Form two layers and cover with a slice of bread sprinkled with the oil, some basil leaves and oregano

CHICKPEA FLOUR FRITTERS

Serves 4
- 375ml (½ cups)
 water
- 125g (1 cup)
 chickpea flour
- 50g (1 cup) Italian
 parsley, chopped
- oil for frying
- salt
- pepper

In a saucepan, mix the chickpea flour in the water.
Place over a medium heat, stirring constantly with
a wooden spoon.

Stir faster and faster until the mixture is
completely firm. Stir in the parsley and, a moment
before it begins to simmer, remove from the heat.

Quickly pour the mixture onto a marble slab and
quickly spread using a wooden spoon to form
a thickness of approximately 7mm.

Allow to cool. Using a sharp knife, cut into
squares.

Fry the fritters in hot oil until golden brown.

Remove from the oil, drain thoroughly and place
on paper towel. Add salt and pepper if you wish.

POTATO CROQUETTES

■ ■ ◻

Serves 4
- 1kg (2$^1/_4$ lbs) floury
 potatoes
- 200g (1$^3/_4$) pecorino
 cheese, grated
- 1 handful chopped
 Italian parsley
- nutmeg (optional)
- 00 flour
- maize or sunflower oil
- salt
- pepper

Boil the potatoes in ample salted water, then drain, peel and mash.

Add the salt, pepper, grated pecorino cheese, a little finely chopped parsley and, if desired, some grated nutmeg.

Let cool, mix well and form the croquettes.

Immediately before frying, lightly coat in flour.

Deep fry the croquettes in hot but not boiling maize or sunflower oil.

Remove with a slotted spoon, place on absorbent paper, add a pinch of salt and serve hot.

Ramì 2009 - Sicilia IGT Bianco
Azienda agricola Cos, Vittoria (Ragusa)

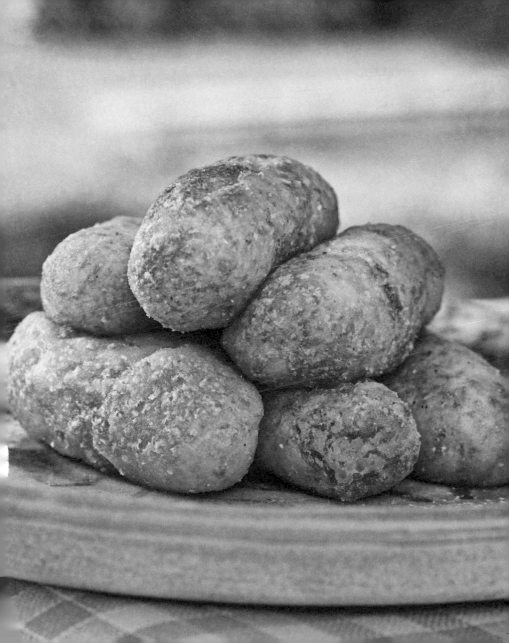

Serves 4
- 2 aubergines
- 2 celery sticks
- 3 carrots
- 1 onion
- 150g (²/₃ cup) basic
 tomato sauce
- 10 pitted white olives
- 2 tablespoons capers
- 100g (³/₄ cup)
 roasted almonds
- 100g (²/₃ cup) raisins
- 2 tablespoons honey
- 1 small bunch of basil
- extra virgin olive oil
- red wine vinegar
- salt
- pepper

AUBERGINE IN SWEET-AND-SOUR SAUCE

Dice the aubergines and fry with a very small amount of oil in a non-stick pan.

Dice the celery and carrot, and finely chop the onion.

Fry the onion in oil, adding the celery and carrot.

Once the vegetables are golden, add the basic tomato sauce and basil leaves, and complete cooking (approximately 10 minutes).

Add the aubergines, salt, pepper, capers, olives, raisins, almonds, honey and vinegar. Evaporate the vinegar and let caramelize.

Serve chilled or at room temperature.

 Etna Rosso 2008 - Etna DOC Rosso
Cantine Graci, Castiglione di Sicilia (Catania)

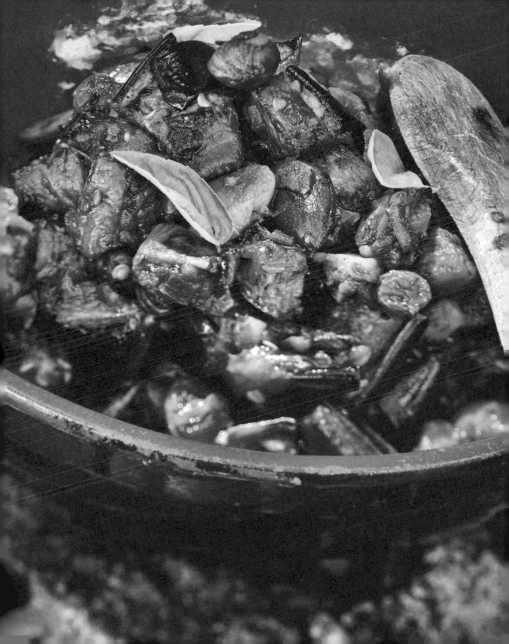

■ ■ ◻

Serves 4
- 4 aubergines
- 700g (1¹/₂ lbs) minced veal
- 2kg (4¹/₂ lbs) tomatoes, peeled and seeded
- 2 onions
- 3 eggs
- 100g (¹/₂ cup) Parmesan cheese, grated
- bread with crusts removed
- milk
- white wine
- basil
- extra virgin olive oil
- fine salt and coarse salt (for brine)
- pepper

AUBERGINE ROLLS

Cut the aubergines into thin slices and soak in cold salted water for 30 minutes.

Remove them from the water, dry thoroughly and fry in hot oil. Remove the excess oil and then salt.

Soak a knob of bread in the milk, squeeze, and mix with the minced meat, eggs and Parmesan cheese. Season with salt and pepper.

Mix well and shape into balls. Place a ball on each slice of aubergine and form a roll.

In a large saucepan, fry the finely sliced onion and add the tomato. Simmer for 10 minutes. Add the basil, and lay the rolls in the mixture.

Sprinkle on plenty of wine, season with salt and pepper, and cook for 30 minutes.

 Ottoventi Bianco 2009 - Sicilia IGT Bianco
Cantina Ottoventi, Trapani

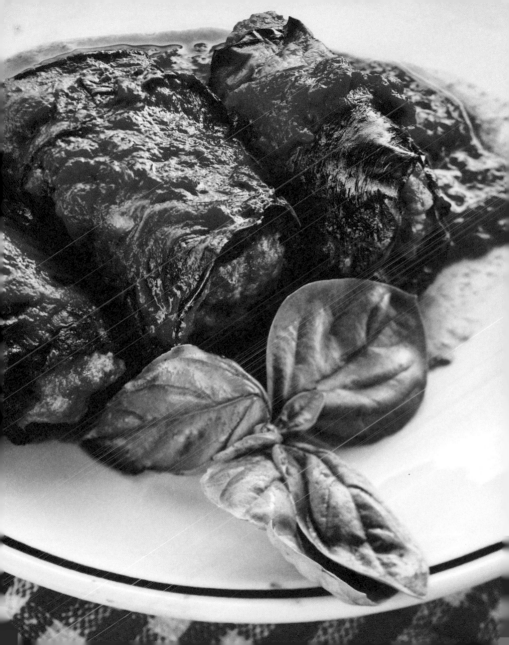

AEOLIAN SALAD

Serves 4
- 800g (1³/₄ lbs)
 tomatoes
- green olives
- capers
- 1 Tropea red onion
- salted anchovies
 (optional)
- oregano
- a few a leaves
- extra virgin olive oil
- red wine vinegar
- salt
- pepper

Cut the tomatoes and combine with the olives, capers, sliced Tropea red onion, oregano, basil, salt and pepper, and a few pieces of salted anchovy (optional).

Drizzle with oil and a dash of vinegar.

Bianco Pomice 2008 - Sicilia IGT Bianco
Cantina Tenuta di Castellaro, Lipari (Messina)

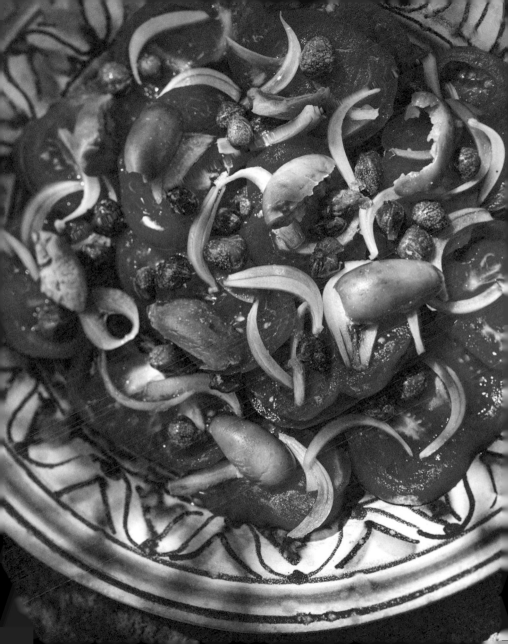

FIRST COURSES

Serves 4
- 500g (1 lb) pasta
 (any shape)
- 500g (1 lb) fresh
 anchovies
- 400g (2²/₃ cups) peas
- 4 spring onions
- 1 teaspoon tomato
 paste
- Italian parsley
- breadcrumbs
 (optional)
- extra virgin olive oil

PASTA WITH PEAS AND ANCHOVIES

Thoroughly clean and scale the anchovies.

Sauté the chopped spring onions in oil.
Add the peas and the tomato paste, dissolved in half a cup of water. Cover until cooked.

Once the peas are cooked, add the anchovies and cook until they fall apart, then add the chopped parsley.

Cook the pasta separately in boiling water.
Drain but leave the pasta a little wet.

Tip the pasta into the pan with the sauce and sauté, adding a little oil if desired.

Optionally serve with toasted breadcrumbs sprinkled over the top.

Zibibbo 2009 - Sicilia IGT Bianco
Cantine Barraco, Marsala (Trapani)

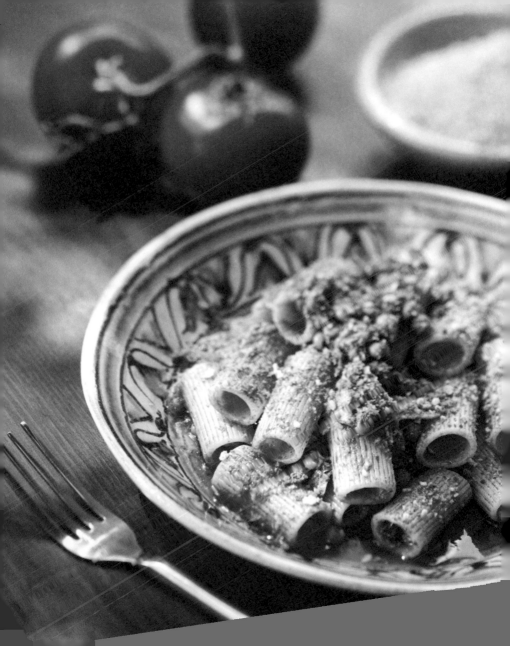

SPAGHETTI WITH PESTO TRAPANI STYLE

Serves 4
- 400g (14 oz) spaghetti
- 200g (5 cups) basil
- 4 garlic cloves
- 150g ($^3/_4$ cup) raw peeled almonds
- 100g ($^2/_3$ cup) crushed raw tomatoes
- extra virgin olive oil
- 1 teaspoon salt

In a blender, combine the garlic, oil and almonds to form a uniform cream.

Add the basil, tomato and oil to form a smooth sauce.

Let the sauce sit while cooking the pasta.

Il Coro 2008 - Sicilia IGT Bianco
Cantina Fondo Antico, Trapani

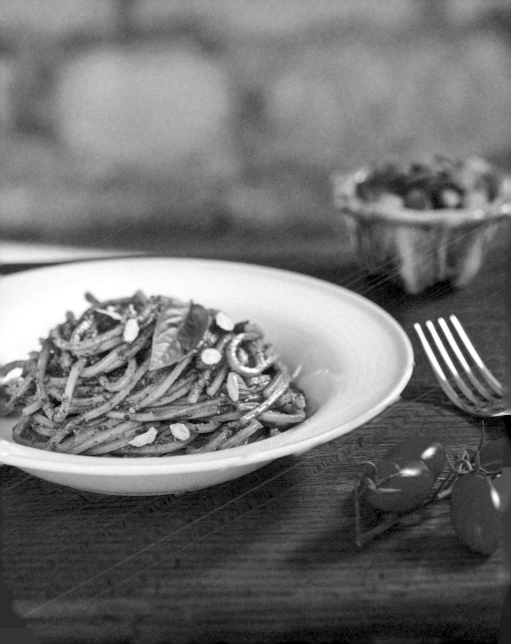

PASTA WITH SQUID INK

■ ■ ☐

Serves 4
- 400g (14 oz) vermicelli or bucatini pasta
- 1kg (2 ¼ lbs) fresh squid
- 100g (⅓ cup) tomato paste
- 2 glasses dry white wine
- 4 spring onions
- grated pecorino cheese
- oregano
- Italian parsley
- 1 pinch ground chilli
- pepper
- extra virgin olive oil
- salt

Remove the ink sacs from the squid and place them in a glass of the oil.

Clean and skin the squid and cut into small pieces.

Chop the spring onions and brown them in the oil. Add the squid and, as soon as it starts sizzling, pour in the wine, previously mixed with the tomato paste.

Lower the heat, add the oregano and chilli, and leave to cook.

Three minutes before cooked, add the squid ink by puncturing the sacs with a fork. Leave to boil for a couple of minutes.

Cook the pasta separately in boiling salted water. Drain the pasta, leaving a little wet, and add to the sauce. Sprinkle with grated pecorino and sauté quickly.

Garnish with chopped parsley.

Suber 2007 - Sicilia IGT Rosso
Azienda agricola Daino, Caltagirone (Catania)

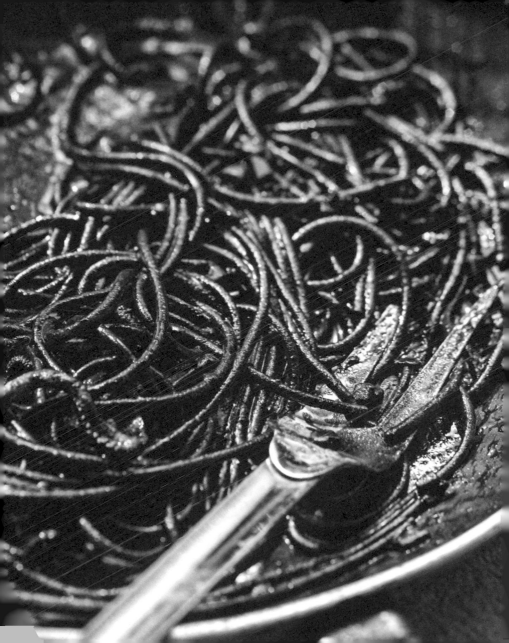

Serves 4
- 400g (14 oz) spaghetti or vermicelli
- 1kg (2 ¼ lbs) ripe tomatoes
- 1 aubergine
- basil
- 2 garlic cloves
- grated salted ricotta cheese
- extra virgin olive oil
- fine salt and coarse
- salt (for brine)

PASTA WITH AUBERGINE, TOMATO, RICOTTA AND BASIL

Cut the tomatoes into quarters, place in an aluminium pot and mash with your hands. Turn the heat to high and boil for approximately 20 minutes.

Pass through a purée sieve and return to the stove, adding the garlic and a generous amount of basil.

Reduce by approximately a third on a high flame. Turn off the heat and add the oil.

Separately, finely slice the aubergines, dip in cold water and salt. Leave under a weight for approximately 1 hour, then drain and squeeze dry.

Fry in hot oil and place on absorbent paper. Cook the spaghetti in ample salted water, leaving quite al dente.

Drain and add the tomato sauce and slices of fried aubergine.

Sprinkle with plenty of grated salted ricotta.

 Etna Rosso 2008 - Etna DOC Rosso
Cantine Barone di Villagrande, Milo (Catania)

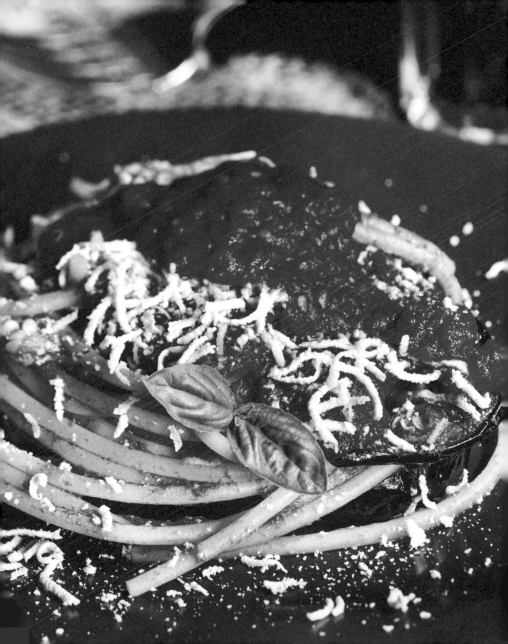

COUSCOUS TRAPANI STYLE

Serves 4
- 1 octopus
- 6 mullet
- 2 snapper
- 2 bream
- 2 rose fish
- 500g (1 lb) shellfish (mussels and clams)
- 4 squid
- 500g (1 lb) ripe tomatoes
- 1 tablespoon tomato paste
- 1 onion
- 2 garlic cloves
- 1 carrot
- 1 small bunch celery
- 2 small chilli peppers
- 1 small bunch Italian parsley
- 1 small bunch basil
- ½ glass white wine
- extra virgin olive oil
- salt

Couscous:
- 1kg (2¼ lbs) pre-cooked couscous
- 1 garlic clove
- 2 tablespoons chopped Italian parsley
- extra virgin olive oil
- salt

In a saucepan, fry the garlic and onion for 5 minutes.

Add the vegetables, parsley, basil, finely chopped tomatoes, chilli peppers and tomato paste dissolved in the wine. Season with salt and cook forapproximately 20 minutes.

Add the cleaned fish and seafood. Bring to the boil and cook for approximately 15 minutes.

Separately in a pan, fry the chopped parsley and chopped garlic. Add the couscous and mix well.

Cover with 1l (4 cups) of warm salted water. Cover the pan until completely absorbed.

Serve the couscous with the soup.

Lolik 2007 - Sicilia Bianco IGT
Cantine Guccione, San Cipirello (Palermo)

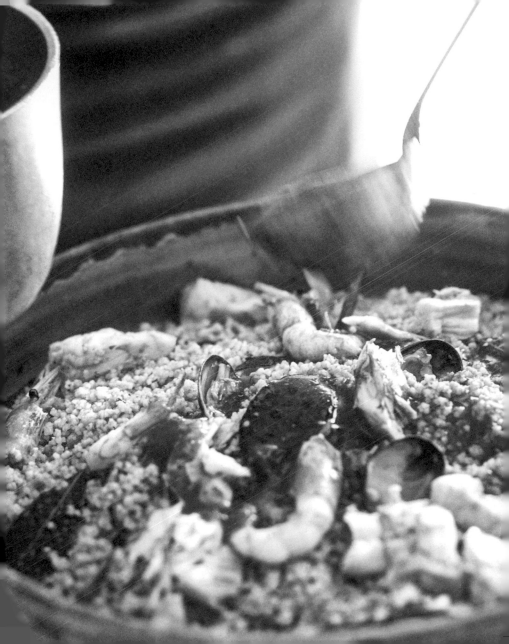

Serves 4
- 280g (1⅓ cups)
 Carnaroli or Vialone
 Nano rice
- 500g (1 lb) stock fish
 (rose fish, bandfish,
 tub gurnard,
 weaverfish)
- 120g (4¼ oz) sea
 urchin roe
- 1.5l (3 pts)water
- 750ml (1½ pts) wine
- 2 shallots
- 1 garlic clove
- Italian parsley
- 1 large pinch of thyme
- 2 bay leaves
- lemon peel (optional)
- extra virgin olive oil
- salt

RISOTTO WITH SEA URCHIN

Put the water, wine, whole shallots, thyme, bay leaves and the thoroughly cleaned stock fish in a deep pan. Bring to the boil over a low heat and simmer for approximately 30 minutes. Turn off the heat and strain the stock.

Separately, heat the oil in a pan with the garlic, removing it as soon as it begins to brown.

Add the rice and fry over a low heat. As soon as the rice is shiny, begin cooking by gradually adding the fish stock and salt.

After approximately 20 minutes, turn off the heat and stir in the sea urchin roe and oil, keeping a couple of spoonfuls of the roe for decorating the plates.

Place a portion of the risotto in the centre of each plate, top with the set aside sea urchin roe, and sprinkle with chopped parsley (optional) and lemon zest.

Grillo 2009 - Sicilia IGT Bianco
Cantine Barraco, Marsala (Trapani)

ANELLETTI PASTA PIE

Fry the onion in the oil until golden, then add the chopped garlic. After a couple of minutes, add the meat and pork rind, and brown for 5 minutes, turning the meat regularly.

Add the tomato paste diluted in the wine and allow to evaporate.

Add the tomato sauce, bay leaf and salt, and cook for 90 minutes over a low heat. Before switching off the heat, add the fresh basil and peas, and cook for another 5 minutes.

Cut the meat into small pieces.

Boil the anelletti pasta in ample salted water, drain and mix with the sauce.

In a buttered baking dish, make a layer of the pasta and sauce, then sprinkle with the flaked cheese. Make a econd layer in the same way, topping with the cheese.

Bake at 180°C (360°F) for approximately 20 minutes.

■■☐

Serves 4
- 450g (16 oz) anelletti pasta
- 200g (7 oz) lean pork
- 200g (7 oz) lean beef
- pork rind cut into strips
- 100g (²/₃ cup) peas
- 1 tablespoon tomato paste
- ½ glass red wine
- ½ onion, chopped
- 2 garlic cloves
- 1 bay leaf
- 2l (4¼ pts) basic tomato sauce
- 6 basil leaves
- butter
- 200g (7 oz) of caciocavallo cheese, in flakes
- extra virgin olive oil
- salt

 Terra delle Sirene - Sicilia IGT Rosso
Azienda agricola Zenner, Catania

AUBERGINE PARMIGIANA

Serves 4
- 8 aubergines
- 1kg (2¼ lbs) ripe
 tomatoes
- 2 onions
- 100g (3½ oz)
 pecorino or
 caciocavallo cheese
- 1 a bunch of basil
- extra virgin olive oil
- coarse salt

Prepare a tomato sauce with the chopped onions, tomatoes and basil.

Slice the aubergines lengthways, without removing the skins, and soak in salted water for a few hours. Drain thoroughly, rinse and dry.

Fry the aubergines on both sides in a pan with plenty of hot oil.

Spread a few tablespoons of the sauce on the bottom of a baking dish.

Alternate each layer of the fried eggplant with the sauce, grated cheese and basil leaves.

Cover the final layer with the sauce and cheese, and bake in a very hot oven for approximately 40 minutes, until a golden crust forms.

 Faro 2007 - Faro DOC Azienda agricola Bonavita, Faro Superiore (Messina)

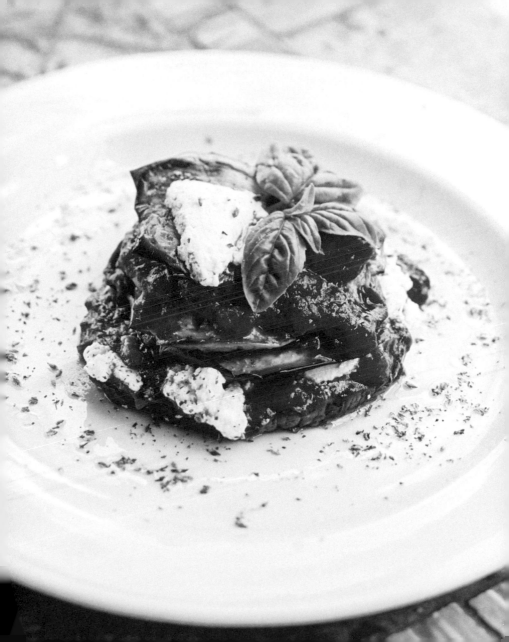

Serves 4
- 400g (14 oz) bucatini
 pasta
- 700g (1½ lbs) fennel
- 10 salted anchovy
 fillets
- 1 onion
- 100g (¾ cup) pine
 nuts
- 100g (⅔ cup) raisins
- extra virgin olive oil
- salt

BUCATINI PASTA WITH 'SARDINES LEFT IN THE SEA'

Boil the fennel in salted water, drain and cut into pieces, setting aside the cooking liquid.

In a frying pan, cook the chopped onion in the olive oil until golden with the pine nuts. Add the raisins and anchovies and cook for another 5 minutes until the anchovies fall apart.

Add the fennel and cook for another 5 minutes.

Boil the pasta in the water used to boil the fennel, drain and serve with the sauce.

Catarratto 2008 - Sicilia IGT Bianco
Cantine Barraco, Marsala (Trapani)

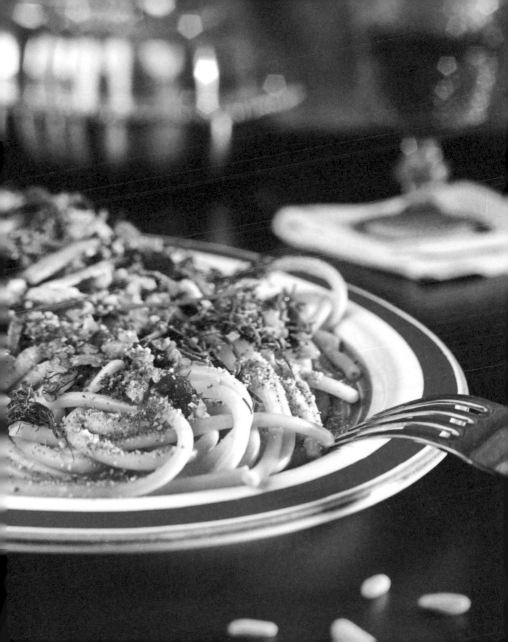

SECOND COURSES

SWEET-AND-SOUR RABBIT

Serves 4
- 1 rabbit cut into
 serving pieces
- 1 celery stalk
- 1 onion
- 2 aubergines
- 20 pitted green olives
- 1 tablespoon capers
- 1 cup basic tomato
 sauce
- seeds of 1
 pomegranate
- 15 toasted almonds,
 chopped fine
- 3 tablespoons honey
- red wine vinegar
- extra virgin olive oil

Fry the rabbit pieces in the oil over
a low heat until golden brown.

Dissolve the honey in a glass of vinegar,
stirring rapidly with a spoon.

Pour the honey over the meat, turning
the pieces repeatedly for a few minutes.
Turn off the flame.

Cut the aubergines into small cubes
and fry in a pan with oil.

Fry the onion, celery, olives and capers for
10 minutes, then add the fried aubergines
and tomato sauce. Leave to cook for another
10 minutes.

Place the rabbit and its cooking liquids into
the sauce and let it absorb the flavours for
10 minutes.

Arrange on plates and let cool. Top with the
pomegranate seeds and chopped toasted
almonds.

 Grillo parlante 2009 - Sicilia IGT Bianco
Cantina Fondo Antico, Trapani

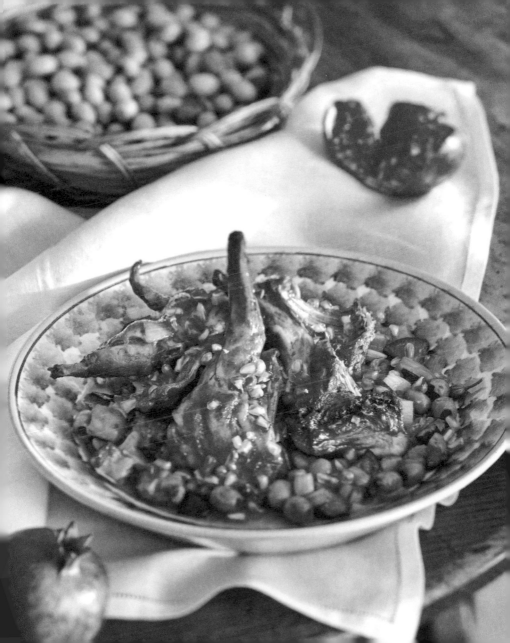

Serves 4
- 400g (14 oz) slice of veal suitable for rolling and stuffing
- 100g (3½ oz) thinly sliced bacon
- 250g (9 oz) minced beef
- 5 eggs
- 1 onion
- 1 large piece fresh bread with crusts removed milk
- 70g (2½ oz) Parmesan cheese
- 2 bay leaves
- 1 sprig rosemary
- nutmeg
- flour
- 2 ladles meat or vegetable broth
- ½ glass dry white wine
- extra virgin olive oil
- salt
- pepper

VEAL ROULADE CATANIA STYLE

Carefully spread, tenderize and even out the veal. Cover completely with the bacon.

Separately, mix the minced beef with 1 egg, the bread oaked in milk, Parmesan, salt, pepper and nutmeg.

Spread the mixture over the bacon.

Separately, hard boil the remaining 4 eggs. Let them cool and remove the shells. Finally, place them whole on the minced meat mixture.

Roll the meat around the eggs so that it is completely closed, carefully sealing the two ends (sew, if necessary) to prevent the eggs from coming out, and tie tightly.

Flour the roll and brown in oil. Allow to rest then dry off the oil.

Chop the onion and fry till golden in oil in a large pan with high sides.

Add the roulade, turn up the heat and pour the wine over the top, letting it evaporate. Add the broth, bay leaves and rosemary.

Seal the pan with aluminium foil and cover. Cook over a very low heat for 30 minutes.

When cooked, allow to cool and cut into thick slices.

Faro 2007 - Faro DOC
Azienda agricola Bonavita, Faro Superiore (Messina)

STUFFED SARDINES CATANIA STYLE

Serves 4
- 800g (1¾ lbs) sardines
- 100g (3½ oz) bread with crusts removed
- 100g (1 cup) aged pecorino cheese, grated
- Italian parsley
- 00 flour
- maize or sunflower oil
- red wine vinegar

Bone the sardines and soak in vinegar for approximately 20 minutes. Dry and lay flat.

Separately, soak the bread in the vinegar. Wring out and mix with the cheese and chopped parsley.

Spread a little of the stuffing on the flesh side of half the sardines. Lie another sardine on the top, forming a kind of sandwich, and seal thoroughly.

Flour and fry in vegetable oil.

Vecchio Samperi Ventennale - Vino liquoroso Cantine Marco De Bartoli, Marsala (Trapani)

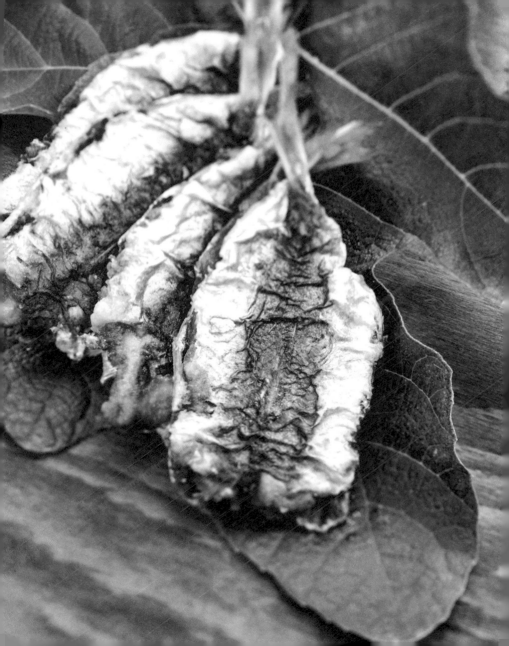

TUNA AND ONION STEAKS WITH SWEET-AND-SOUR SAUCE

■ ■ ▢

Serves 4
- 800g (1³/₄ lbs) tuna steak
- 350g (12 oz) onions
- a few fresh peppermint leaves
- extra virgin olive oil
- 100g (¹/₃ cup) red wine vinegar
- 100g (³/₄ cup) fine sugar
- salt

Marinade:
- 10 juniper seeds
- 5 cardamom seeds
- 1 large pinch cumin
- 1 large pinch fennel seeds
- 200g (1 cup) cane sugar
- 100g (¹/₃ cup) salt

Marinate the tuna the day before: mix the spices with the cane sugar and salt, and coat the tuna. Place in a baking dish, cover with plastic wrap and refrigerate for 24 hours. Once finished marinating, clean the tuna, rinsing it under water and dry thoroughly.

Trim the tuna, removing the darkest and most irregular parts. Dice and grill in a non-stick pan, leaving the meat still rare.

Cut the onion into uniform slices and steam for 5 minutes. Immerse in iced water, drain and dry.

Place the onion in a pan with oil and salt, turn up the flame and brown well. Add the vinegar, fine sugar and peppermint, and allow to caramelize.

Place a little of the sweet-and-sour onion mixture in the centre of each plate. Arrange the tuna scallopina on top and cover with a little of the sweet-and-sour auce.

San Lorenzo 2007 - Etna DOC Rosso
Cantina Girolamo Russo, Randazzo (Catania)

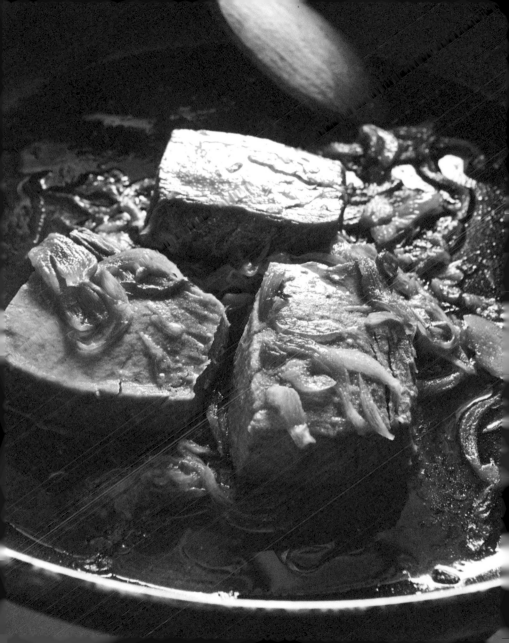

TASTY SWORDFISH

🔲⬜⬜

Serves 4
- 300g (10½ oz) swordfish, sliced
- 200g (7 oz) potatoes
- 200g (7 oz) canned peeled tomatoes
- ½ onion
- green olives, pitted
- 1 tablespoon desalinated capers
- basil
- chilli pepper
- extra virgin olive oil
- salt
- pepper

Sauté the chopped onion in plenty of oil and add the olives, desalinated capers, peeled tomatoes, chilli pepper, salt and pepper.

Cook for 20 minutes.

Add the swordfish and cook for a further 5 minutes.

Boil the potatoes separately. Peel and slice them, then add to the fish. Sprinkle with chopped basil.

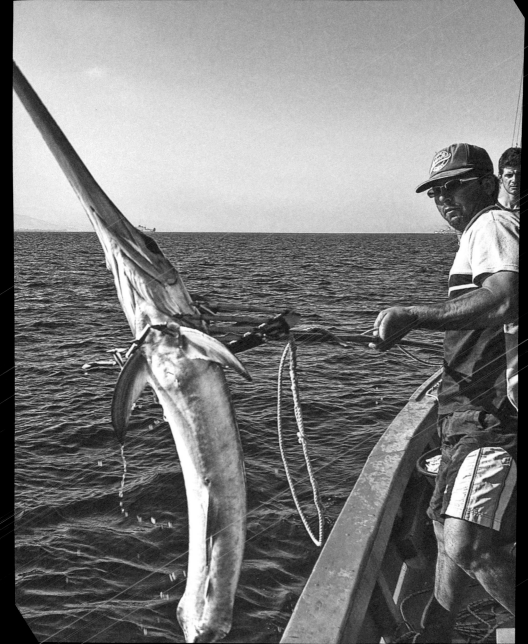

COD PALERMO STYLE

Serves 4
- 1 kg (2¼ lbs) medium cod
- 8 salted anchovies
- 150g (1¼ cups) breadcrumbs
- 100g (1²/₃ cups Italian parsley, chopped
- 1 tablespoon rosemary
- extra virgin olive oil
- lemon juice
- salt
- pepper

Clean the cod.

Fry the anchovies in 2 tablespoons of oil until they fall apart.

Spread the fried anchovies on the cod, then sprinkle with breadcrumbs, parsley, rosemary, salt and pepper.

Place the cod in an oiled baking tray.

Bake in a preheated oven at 180°C (360°F) for 20–30 minutes.

Before serving, sprinkle with lemon juice.

Maquè Rosé - Sicilia IGT Rosato
Azienda agricola Porta del Vento,
Camporeale (Palermo)

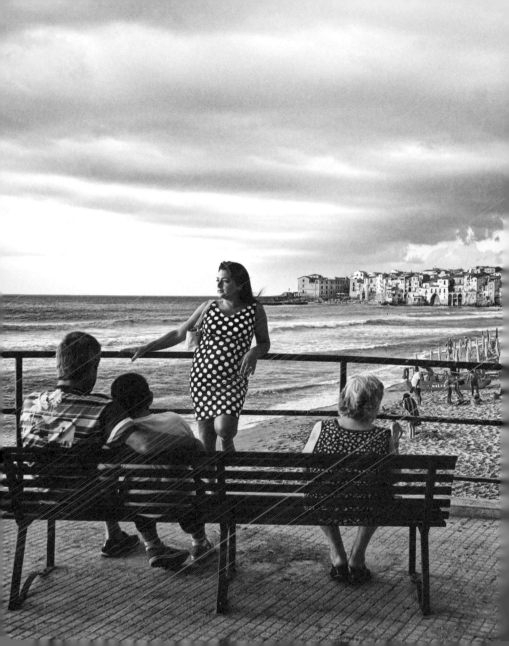

DESSERTS

ALMOND BISCUITS

Ingredients
- 1kg (2¼ lbs) blanched almonds
- 1kg (2¼ lbs) sugar
- 240g (1 cup) egg whites
- vanilla essence to taste (2-3 drops)
- bitter almond essence to taste (3-4 drops)

Chop the almonds together with the sugar as finely as possible.

Add the egg whites and the vanilla and bitter almond essence (do not exceed the recommended quantities in order to avoid making the biscuits bitter). Beat the mixture until soft.

Place a little at a time in a pastry bag and start to make the biscuits.

Lightly press half a glacé cherry or an almond on top of each.

Allow to rest overnight.

The following morning bake at 180 °C (360°F) for about 8 minutes until golden. Remove from the oven and allow to cool thoroughly in order to prevent the biscuits from sticking to the baking tray.

 Malvasia delle Lipari - Malvasia delle Lipari DOC Azienda Agricola Caravaglio, Malfa (Messina)

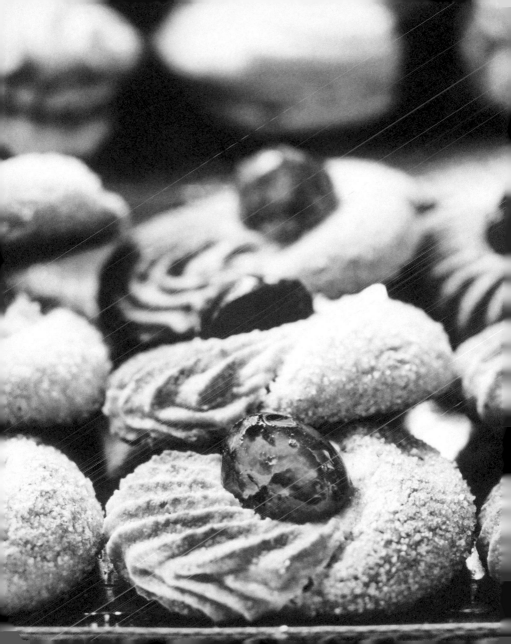

SICILIAN CANNOLI

Ingredients
Cannoli:
- 800g (7 cups) durum wheat flour
- 4 egg yolks
- 2 egg whites
- 150g (5¼ oz) shortening
- 75g (⅓ cup) sugar
- ½ glass white wine
- vanilla flavouring
- oil for frying

Filling:
- 1kg (2¼ lbs) sheep's milk ricotta
- 350g (1¾ cups) sugar
- 100g (¾ cup) candied fruit
- 100g (1 cup) cooking chocolate, flaked
- 1 tablespoon cinnamon
- icing sugar

Mix the flour, egg yolks, egg whites, shortening, sugar, white wine and vanilla flavouring to a smooth dough.

Roll thinly and cut out circles with a 10cm wide glass or round cutter.

Wrap the circles around cane or metal cannoli moulds.

Fry the cannoli in boiling oil until golden brown.

Separately, combine the ricotta and sugar, adding the candied fruit and chocolate.

Fill the cannoli and sprinkle with cinnamon and icing sugar.

Passito di Pantelleria 2005
Passito di Pantelleria DOC
Cantine Ferrandes, Pantelleria (Trapani)

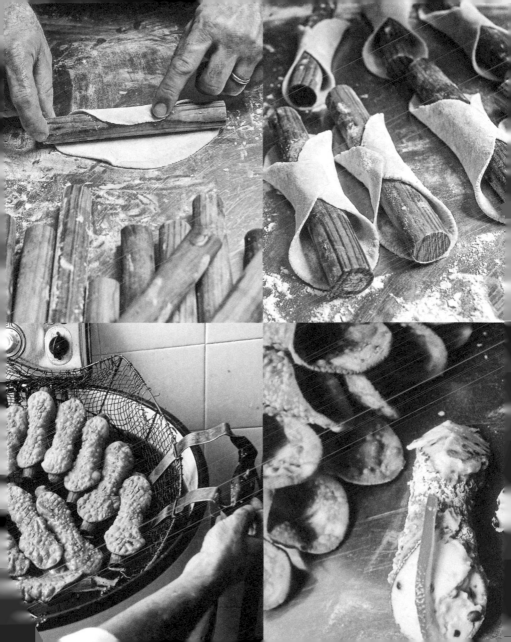

CINNAMON JELLY

Serves 4
- 600ml (2¹/₂ cups) water
- ³/₄ cinnamon stick
- 130g (²/₃ cup) sugar
- 50g (¹/₃ cup) wheat starch or cornflour
- chopped pistachio or hazel nuts, or flaked chocolate, for garnish

The day before, place the coarsely chopped cinnamon in a saucepan with 3 litres (6¹/₃ pts) of water. Bring to the boil. Simmer for approximately 10 minutes. Turn off the heat and allow to infuse overnight.

The next day, thoroughly strain the infusion and add water to bring the amount up to 600 millilitres (1 pt).

While cold, add the sugar and starch, and mix with a whisk.

Place on a low heat and, stirring constantly with a wooden spoon, bring to the boil, then turn off.

Immediately pour into disposable moulds, dampened with cold water, let cool and refrigerate.

Serve topped with chopped pistachio or hazelnuts, or flaked chocolate.

 Sultana 2009 - Sicilia IGT Moscato
Cantina Feudo Maccari, Noto (Ragusa)

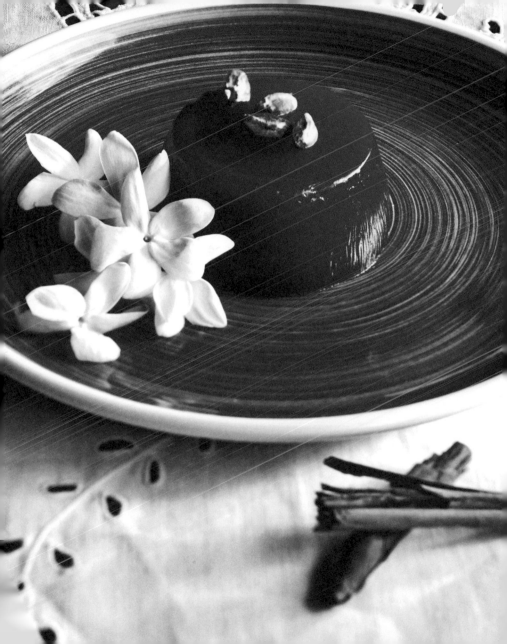

JASMINE BLANCMANGE

Serves 4
- 20 jasmine flowers
- 500ml (1 pt)
 full-cream milk
- 50g (1¾ oz) white
 chocolate
- 50g (⅓ cup) cornflour
- 100g (½ cup) sugar

Pour the milk into a saucepan and add the jasmine flowers.

Bring just to the boil and turn off immediately. Allow to cool completely.

Strain, squeezing the flowers gently with your fingers to extract the flavour.

Add the cornflour to the sugar and mix thoroughly to avoid lumps.

Add the grated white chocolate.

Place on the stove and stir continuously until thickened.

Stir briskly for one more minute after the liquid boils then turn off.

Pour the mixture into moulds, allow to cool and refrigerate for 2 hours.

Moscato di Pantelleria 2009
Moscato di Pantelleria DOC
Cantina Solidea, Pantelleria (Trapani)

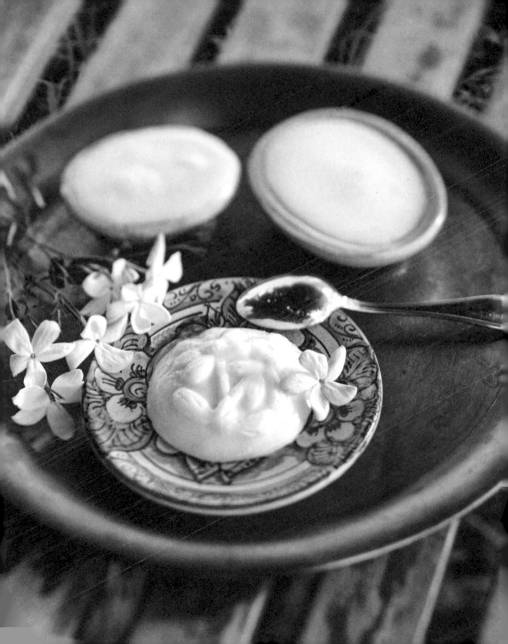

LEMON SORBET

Serves 4
- 500ml (1 pt) lemon juice
- 2.5l (5¼ cups) water
- 1 egg white
- 200g (1½ cups) fine sugar
- 50g (¼ cup) icing sugar

Boil the water and sugar in a saucepan for several minutes until all the sugar has dissolved. Allow to cool.

Beat the egg white to peaks in a double boiler with the icing sugar.

Combine the lemon juice and sugar syrup, and add the egg, stirring gently.

Freeze for approximately 4 hours, stirring occasionally.

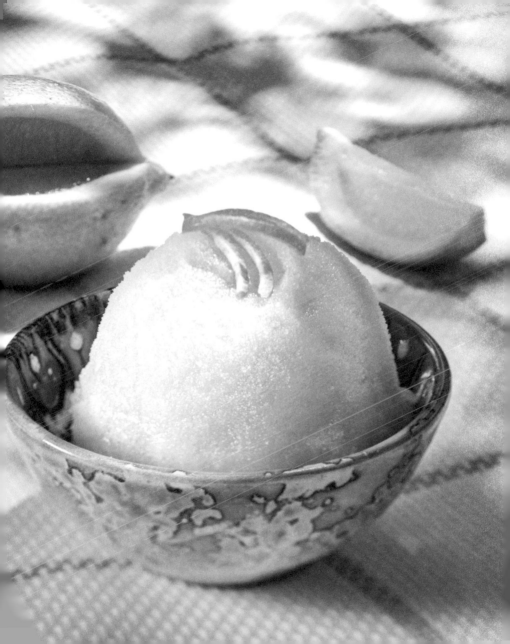

RICOTTA CAKE

■ ■ ◻

Ingredients
- sponge cake
- 1kg (2¼ lbs) sheep's milk ricotta
- 370g (2 cups) sugar
- 50ml (3 ⅓ tablespoons) maraschino liqueur
- 100g (3½) plain chocolate in small pieces
- apricot jam
- 80g (⅔ cup) candied fruit, diced
- whole candied fruit for garnish

Icing:
- 300g (1½ cups) icing sugar
- 2 tablespoons milk
- juice of ½ lemon

Line the bottom and sides of a round cake tin with greaseproof paper.

Coat the paper with the apricot jam and then line with thin slices of sponge cake.

Mix the ricotta with the sugar, maraschino liqueur, diced candied fruit and chocolate.

Fill the pan with the ricotta mixture, level, and close with a circle of sponge cake.

Allow to stand for 2 hours.

Using a larger plate than the cake tin, upend the tin to remove the cake, then remove the greaseproof paper.

Prepare the icing by mixing all the ingredients in a bowl with a spoon.

Cover the entire surface of the cake with the icing and decorate with the whole candied fruits. Refrigerate for 2 hours

Passito di Pantelleria 2005
Passito di Pantelleria DOC
Cantine Ferrandes, Pantelleria (Trapani)

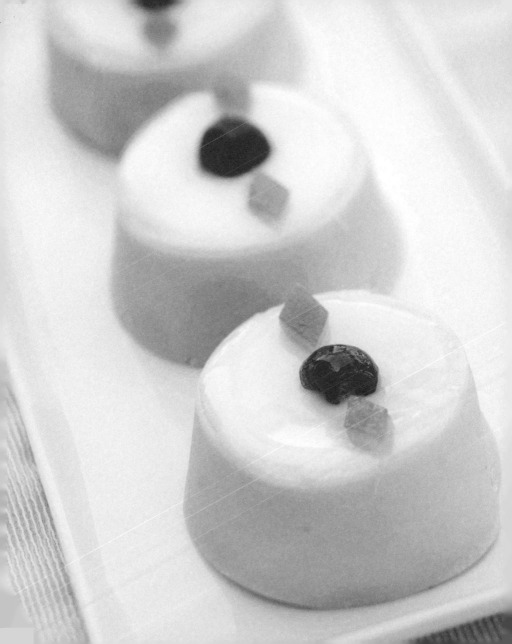

FRUITS OF MARTORANA

Ingredients
- 800g (4²/₃ cups) raw almonds
- 530g (2³/ cups) sugar
- 100g (²/₃ cup) 00 flour

Finely chop the almonds to a powder.

Dissolve the sugar in ½ cup of water over a low heat, stirring constantly.

As soon as the sugar begins to thread, add the ground almonds and then the flour.

Stir over a low heat, until firm. When almost hard, it will no longer stick to the pan.

Allow the dough to cool and then knead lightly into the desired shape.

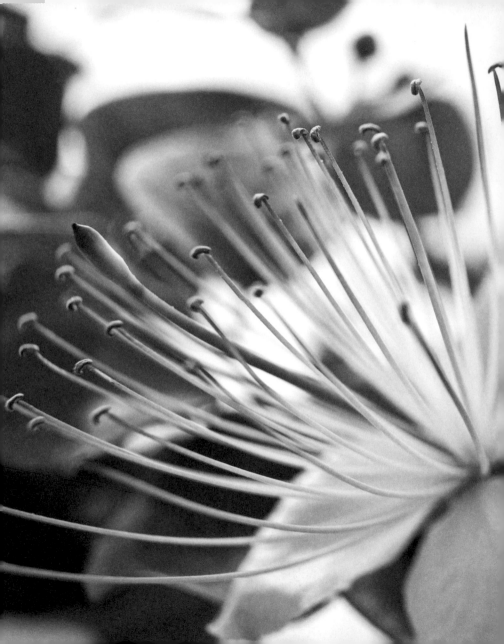

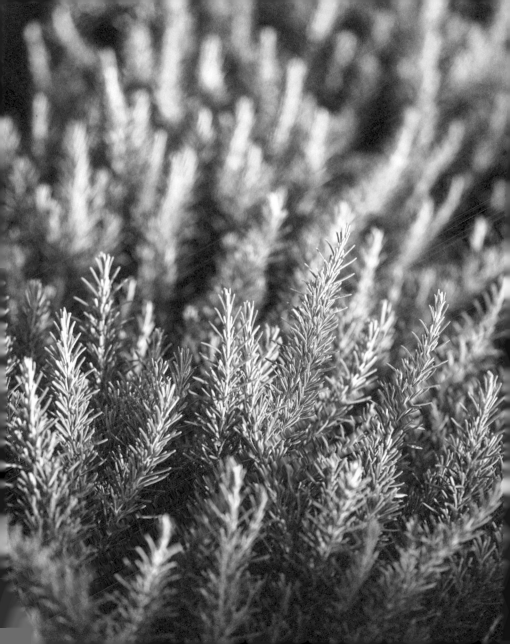

Bay laurel *(Laurus nobilis)*
Introduced to Sicily in antiquity, the bay laurel originates in Asia. It's a perennial shrub whose leaves are rich in essential oils. It grows well in full sun or shade, but cannot withstand strong winds. Its leaves are used in sauces and meat and fish dishes, while its seeds form the basis of a unique tasting liqueur.

Caper *(Capparis spinosa)*
The caper bush can grow in even the harshest conditions. It loses its leaves in winter and then blooms in May, with brightly coloured flowers similar in appearance to orchids. The flowers are highly perfumed and open in the morning or at dusk, only surviving a few hours. The young flower buds are the part used. In brine or vinegar, capers are ideal for salads, and fish and meat dishes.

Fennel *(Foeniculum vulgare)*
Fennel flowers in summer. Almost the entire plant is used: the flowers, the stem and the leaves. It goes well with fish dishes and delicate cheeses. In Palermo, it's widely used in pasta with sardines.

Garden sage *(Salvia officinalis)*
Known since Ancient Egypt, garden sage

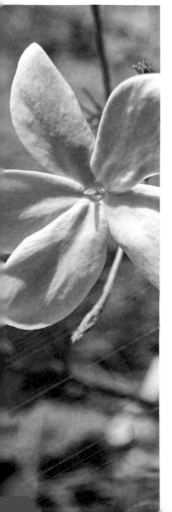

flourishes in mild climates. Its aroma is so intense that it can cancel out the flavour of other herbs. It is an essential herb for meat and fish.

Jasmine *(Jasminum officinale)*
Although originally from Asia, this plant is widespread in Sicily. The scent of its flowers fills the air all along coastal and country roads. Its flowers are used in desserts, jams and liqueurs.

Lemon verbena *(Lippia citriodora)*
This shrub cannot tolerate low temperatures and prefers full sun. It flowers in summer and loses its leaves in winter. Its spear-shaped light green leaves give off a citrus aroma that goes well with fish. It's excellent for making teas and spirits but is also used to flavour fruit salads and ice cream.

Lesser calamint *(Calamintha nepeta)*
This shrub is highly heat resistant and doesn't require frequent watering. It's used to season meat, fish and mushrooms. In Syracuse its leaves are blended with other seasonings on focaccias, while in Ragusa they are used in water to boil dried figs.

Marjoram *(Origanum majorana)*
The same genus as oregano but with a more delicate aroma, marjoram is highly resistant to harsh climates and flowers throughout spring and summer. It's ideal for seasoning meat and fish dishes. In Ragusa it's used with ricotta as a ravioli filling.

Oregano *(Origanum heracleoticum)*
A cornerstone of Sicilian cuisine, the plant is hardy and adapts well to temperature changes. The variety with the white flower is the most fragrant and typical of the Hyblaean Mountains. It flowers in June, producing spikes of colourful fragrant blooms. After harvesting, oregano is dried in the dark, then crumbled into an airtight jar.

Peppermint *(Mentha spicata)*
The peppermint is a symbol of virtue for its ability to grow back even if 'mistreated'. It quickly propagates and can easily become invasive. It does not tolerate full sun. Excellent as a fresh herb in drinks, it's also used to flavour meat, aubergines and olives.

Rock samphire *(Crithmum maritimum)*
This plant has succulent leaves and flowers from June to September. Tolerant of harsh

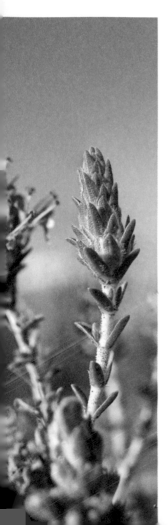

climates, it grows year-round near the sea. The leaves can be used fresh in salads or preserved in vinegar or oil. It complements fish.

Rosemary *(Rosmarinus officinalis)*
This hardy plant with a pungent, penetrating fragrance is very resistant to high temperatures because of its small, narrow leaves that limit water loss. It's widely used in meat and fish dishes.

Wild thyme *(Thymus capitatus)*
This hardy plant grows at both low and high altitudes. Its inebriating fragrance fills the air all along the coast of Ragusa, where it flowers in June and July. It's excellent for seasoning meats in general and is used for producing the rare 'Satra' honey.

GLOSSARY

Arancino
A fried rice ball stuffed with meat sauce and peas. It can also be flat and round or conical. In some parts of Sicily, they are called *arancina*.

Beccafico
A bird of the Sylvidae family that's particularly fond of figs. The stuffed sardine dish 'Sarde a beccafico' takes its name from the way the greedy bird stuffs itself with the fruit.

Blancmange
A semi-solid milk-based dessert.

Caciocavallo
A semi-hard stretched-curd cheese made exclusively from cow's milk.
The DOP (protected designation of origin) caciocavallo made in Ragusa is box shaped.

Caponata
A mixture of fried vegetables, mainly aubergines, with a sweet-and-sour sauce of tomatoes, onion, celery, capers and olives. It's served as an antipasto or side dish. There are numerous variations with different ingredients.

Cazzilli
An informal expression for croquettes (potato and other)

Couscous
Granules of semolina wheat, served steamed with vegetables, stewed meat and fish soups. North African in origin, couscous is widespread in Sicily.

Cunzatu
Literally, 'seasoned' – e.g. 'Pani cunzatu'.

Farsumagru
The name of this traditional Sicilian meat dish apparently derives from the French farcie de maigre (stuffed with lean), because of its meat-free filling. Farsumagru is a kind of roulade, whose filling varies throughout Sicily.

Fruits of Martorana
Marzipan sweets shaped like different fruits, vegetables or anything. The name derives from the Sicilian noblewoman Eloisa Martorana, who, in the late 12th century, founded the convent of the same name in Palermo. The nuns of the convent apparently excelled in the preparation of desserts.

Gelo
A dessert with a similar consistency to jelly.

Mafalde
A soft bun covered with sesame seeds.

Maiorchino
A hard cheese made from full-cream sheep's milk in some of the towns around Messina. It has a delicate flavour, becoming sharper after its minimum aging of eight months. Each wheel weighs around 10–12 kilograms. Masculina da magghia Fresh young anchovies.

Nnocca
'Flake'. The dish 'Pasta ca' nnocca' (pasta with sardines and peas) takes its name from the appearance of the pasta and the dish itself

Panelle
Chickpea flour pancakes made in many parts of the island. They are generally eaten in a mafalda (→).

Pecorino
A hard cheese made exclusively from full-cream sheep's milk in a cylindrical shape. It is known as *tuma* when eaten immediately after production, *primosale* if salted and eaten within ten 10 days, secondo sale if eaten between 45 and 90 days, and *stagionato* (aged) after four to six months.

Primosale
→ Pecorino

Ricotta
A fresh cheese made from the whey of cow's, sheep's or goat's milk, or a mixture, with a delicate flavour.

Sorbetto
A cold dessert with a velvety consistency made from water and sugar with the addition of fruit pulp or juice.

Stimpirata
An informal expression for sweet-and-sour – e.g. 'Coniglio alla stimpirata' (sweet-and-sour rabbit).

Tarocco
The best known Sicilian blood orange variety. It has IGP (protected geographical indication) certification.

Tuma
→ Pecorino.

Vastedda
A delicate and fragrant stretched-curd goat cheese typical of the Valle del Belice. It's eaten as fresh as possible.

INDEX OF RECIPES

Editing
William Dello Russo
Translation
Chris Turner
Photoeditor
Giovanni Simeone
Design and Layout
Jenny Biffis
Prepress
Fabio Mascanzoni

ISBN 978-88-95218-18-2

Printed in Europe by Factor Druk, Kharkiv

Sime srl
Tel. +39 0438 402581
www.sime-books.com

This book is an excerpt of:

"SICILIA IN CUCINA
THE FLAVOURS OF SICILY"

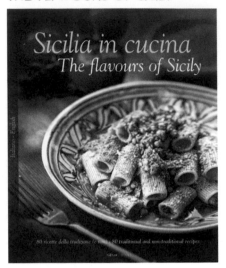

80 ricette della tradizione (e non)
80 traditional and non-traditional recipes

Edited by William Dello Russo
Photographs by Antonino Bartuccio,
Alessandro Saffo

Hardback
Italiano/English
288 pages
19,5 x 23,5 cm
ISBN 9788895218212
26,00 €

www.sime-books.com